MW00608512

In 1974, when he had just finished his photography studies with Otto Steinert in Essen, Timm Rautert set off to Pennsylvania, USA, to take photos of those who actually do not let themselves be photographed.

The Amish are an Anabaptist Protestant community of faith founded by Jakob Ammann (1644–1730), a Swiss Mennonite who dictated a devout, humble way of life detached from the civilized world. Persecuted in seventeenth-century Europe, the Amish immigrated to America in the eighteenth century, where they sought greater religious freedom. They still live there, following the strict rules of the Bible – even a passport, for example, may not be issued with a photograph.

The religious community of the Hutterites – whom Timm Rautert visited in 1978 in the Canadian province of Alberta close to the American border – also live according to the strict rules of the Bible. They, too, are an Anabaptist community of faith which, founded in 1528, goes back to the teachings of Jakob Hutter (approx. 1500–1536), its followers living in communal societies. Persecuted ever since the founding of their church – Jakob Hutter died for his faith at the stake in Innsbruck in 1536 – they immigrated to North America between 1874 and 1879. Both communities speak a peculiar, old-fashioned German as their mother tongue.

The present book brings together, for the first time, the two photographic series significant for Timm Rautert's later oeuvre. In contrast to the Amish series – captured in classic black-and-white photography – Rautert chose a Kodachrome color film for his photographs of the Hutterites.

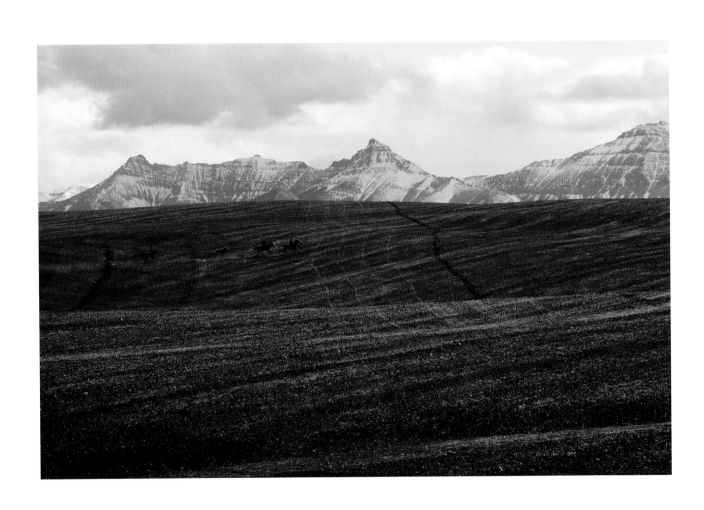

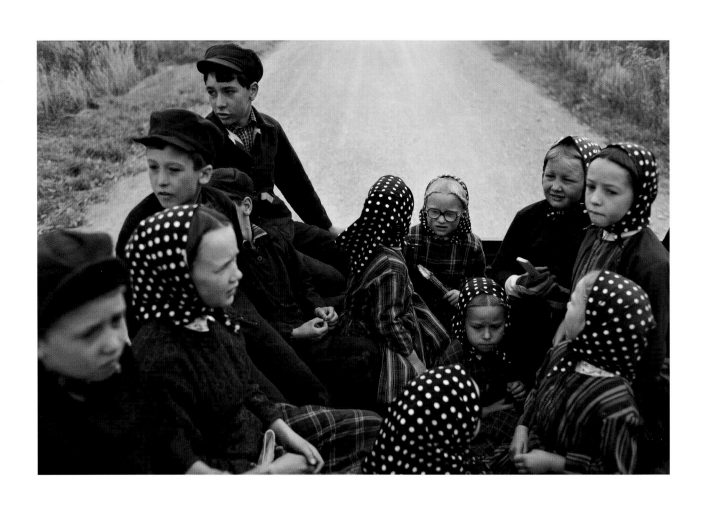

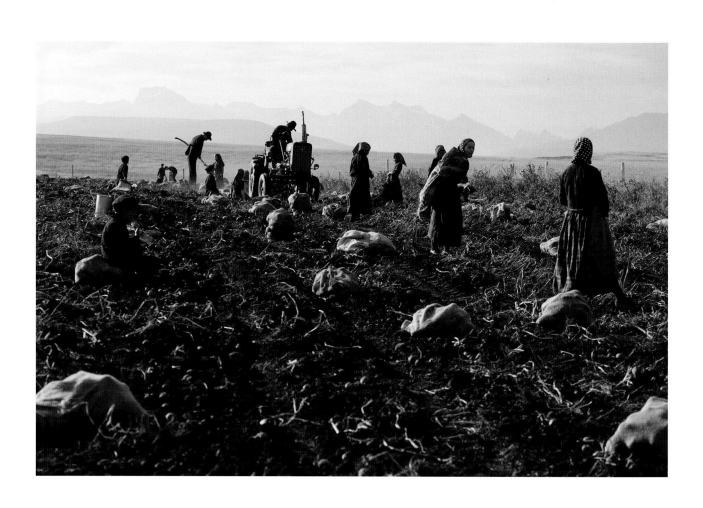

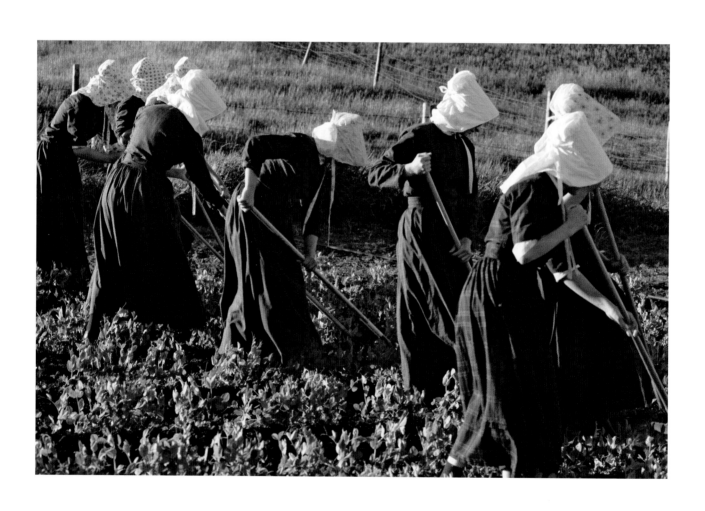

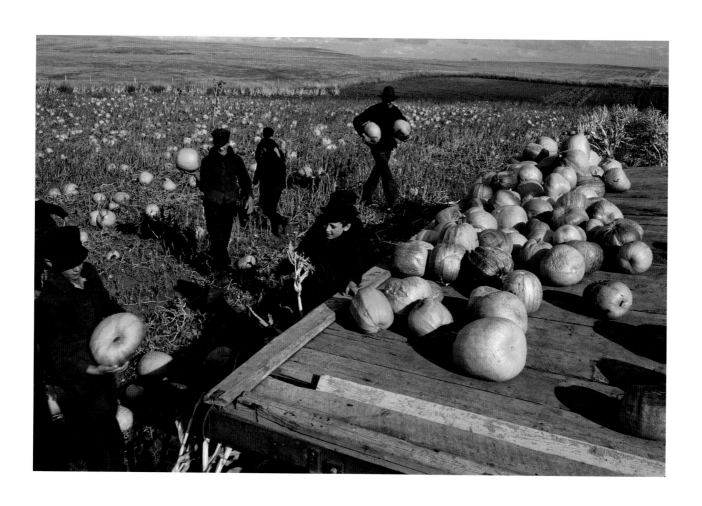

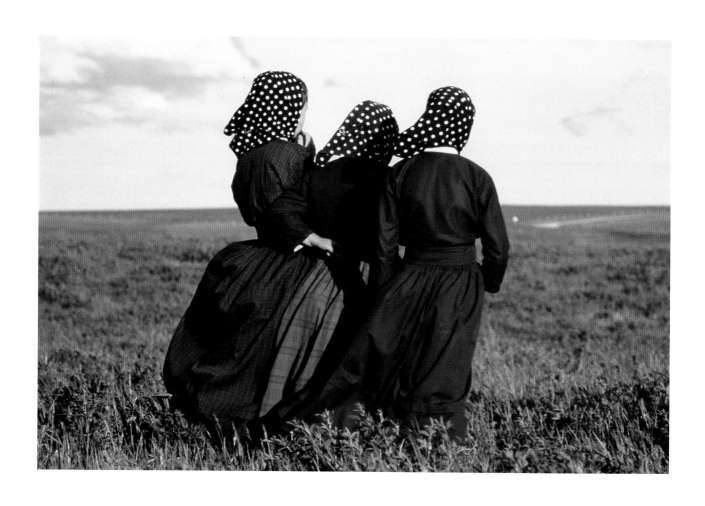

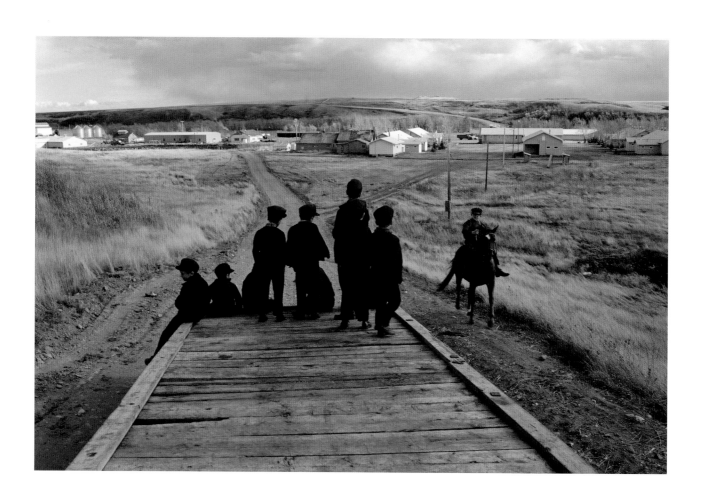

•NO•
PHOTOGRAPHING

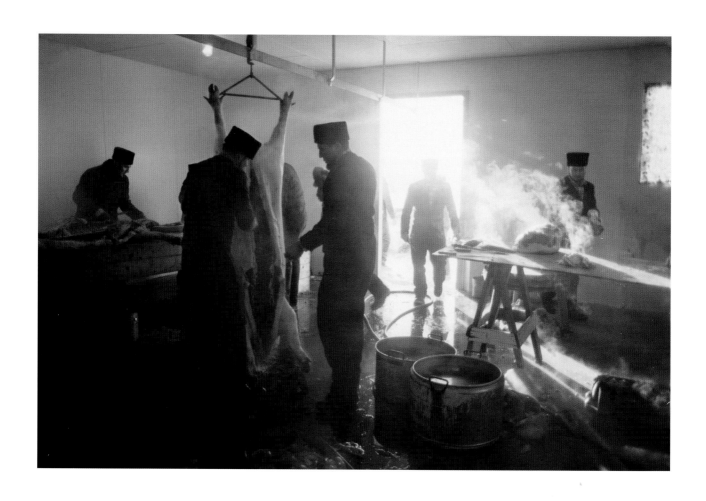

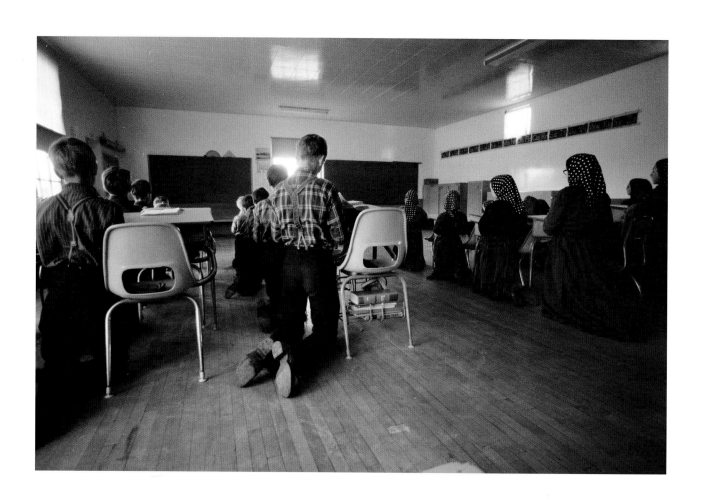

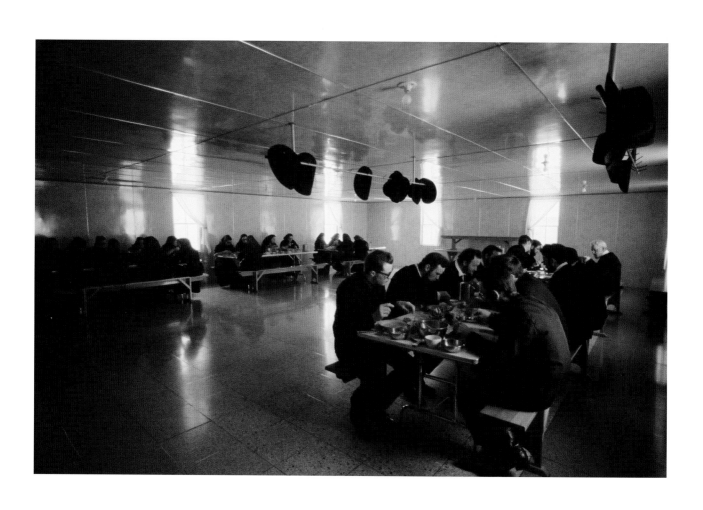

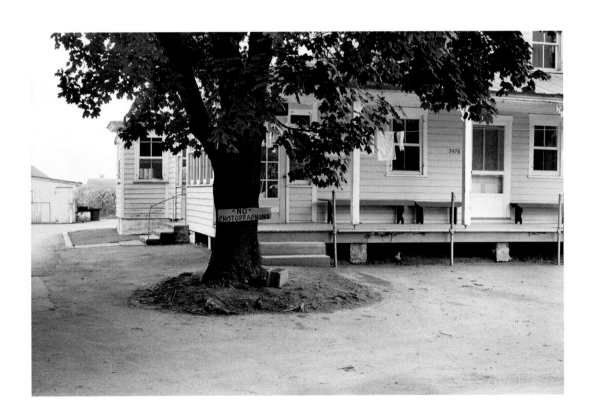

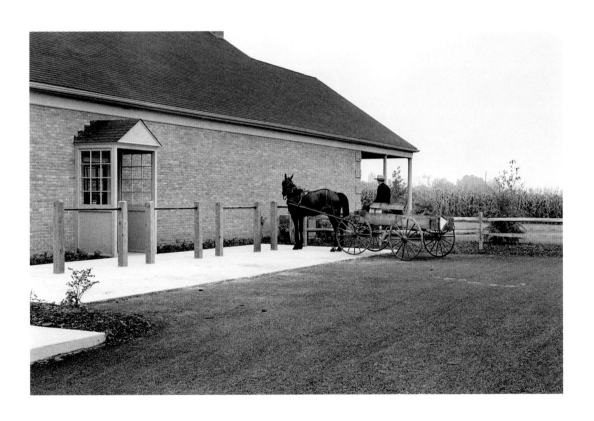

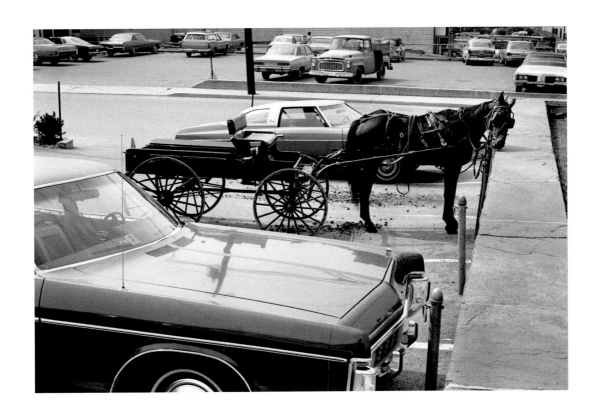

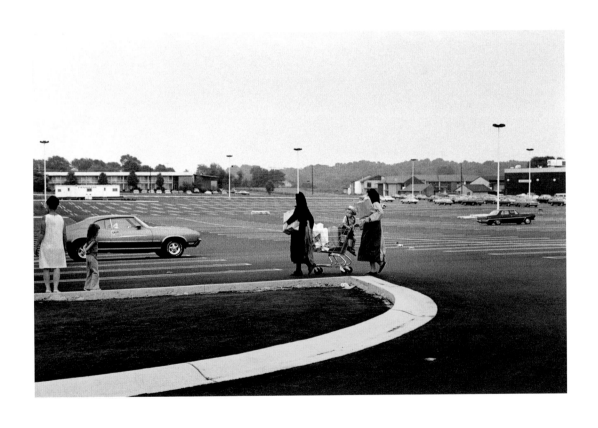

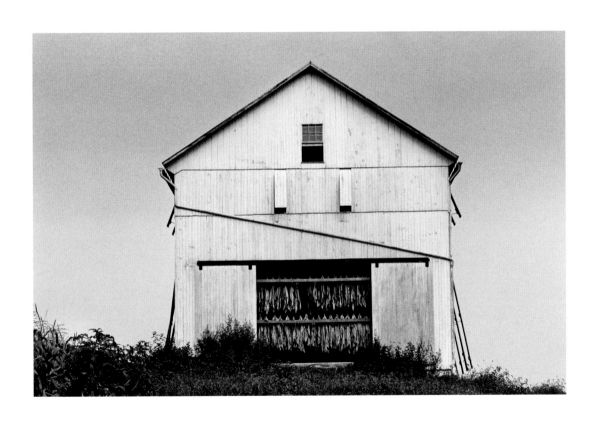

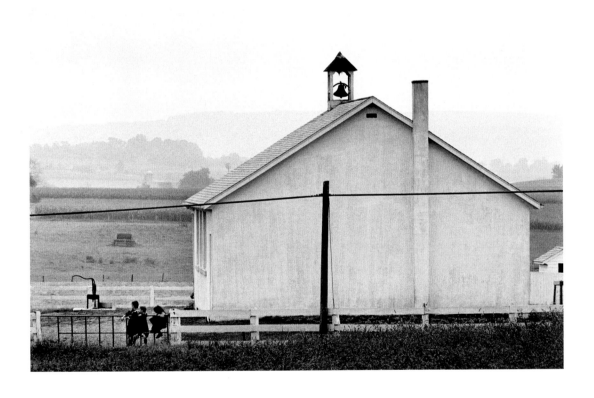

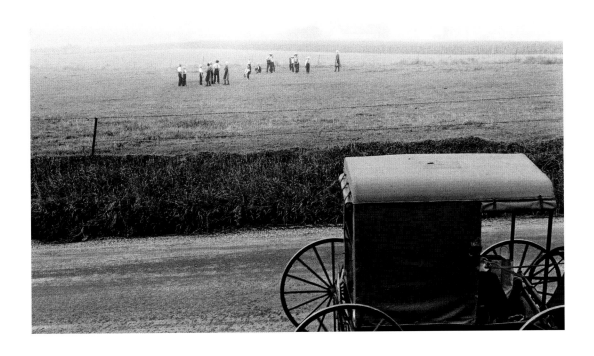

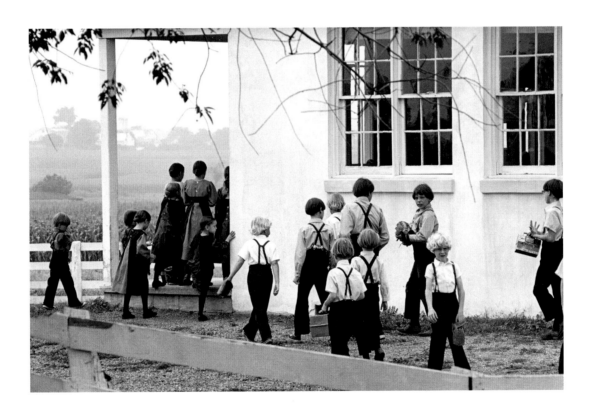

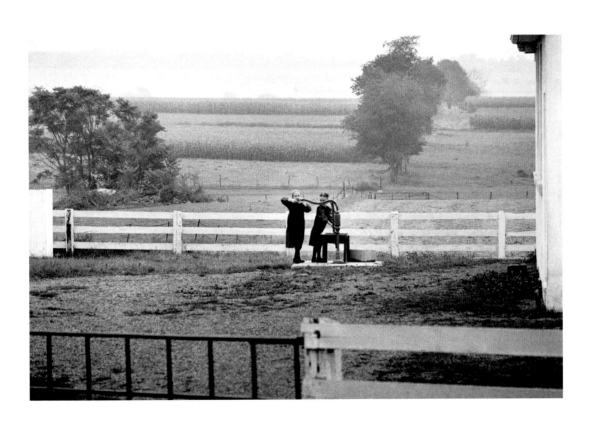

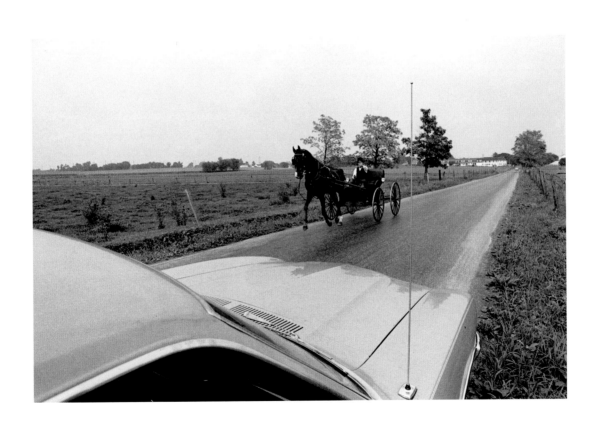

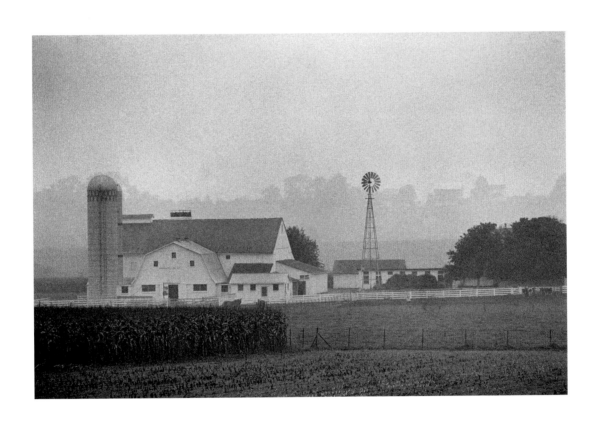

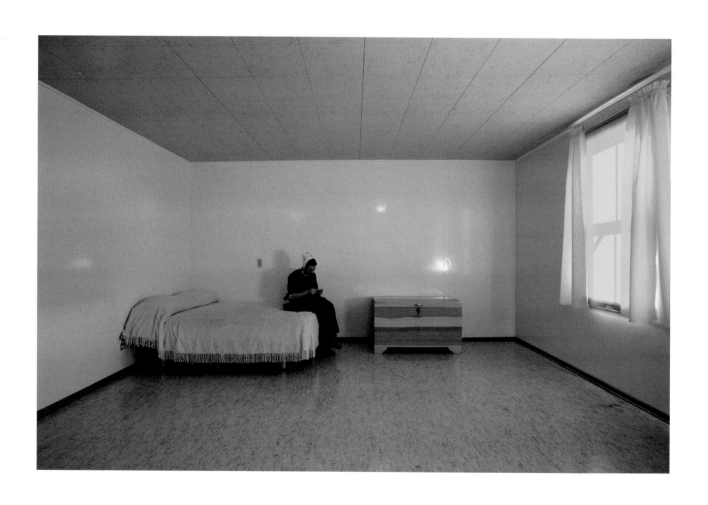

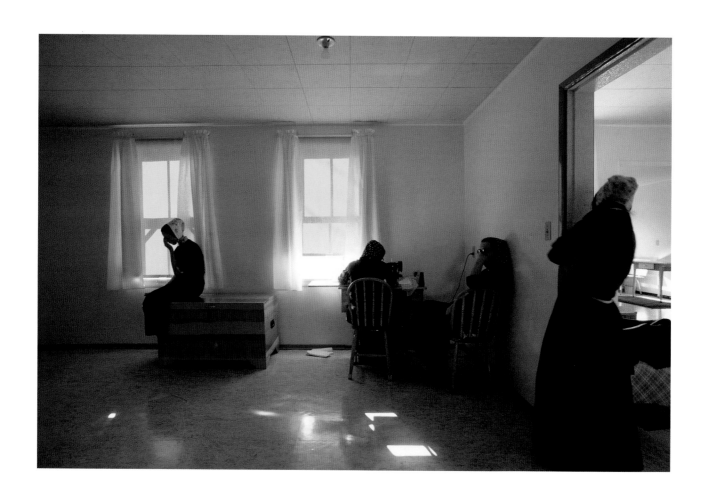

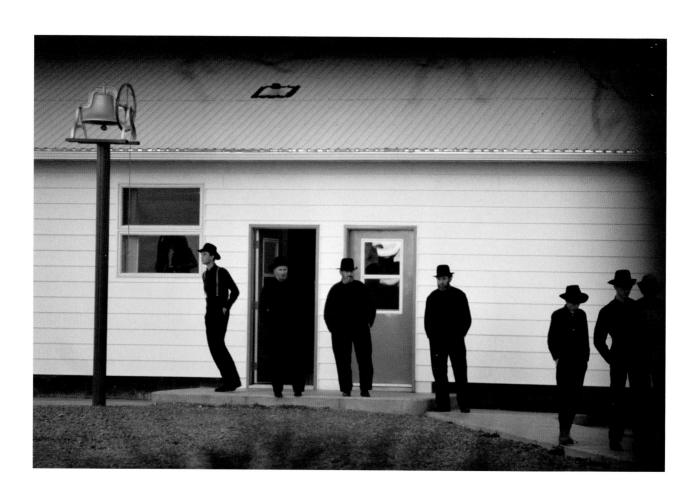

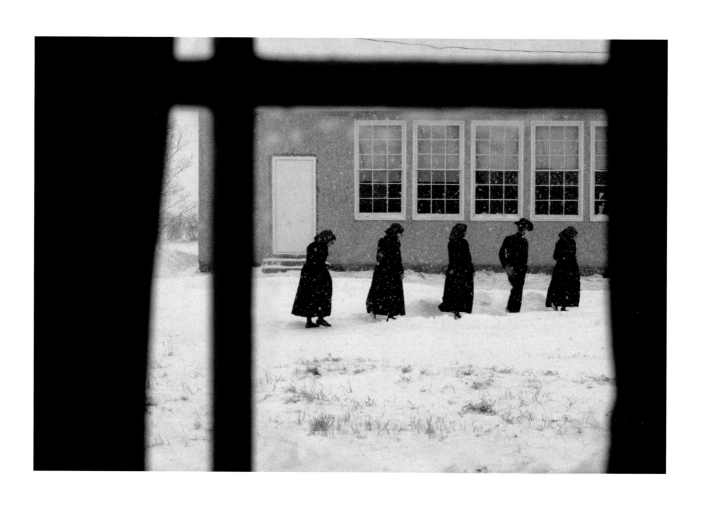

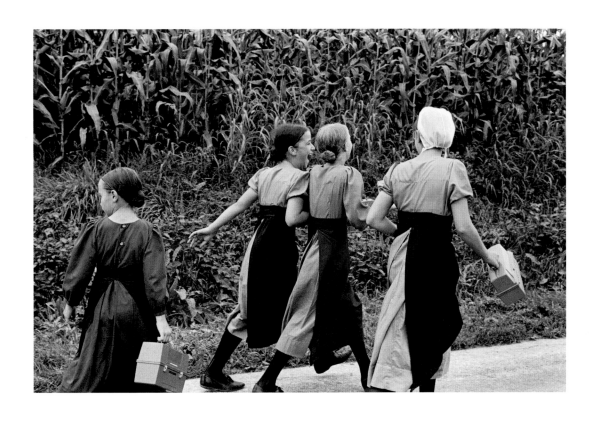

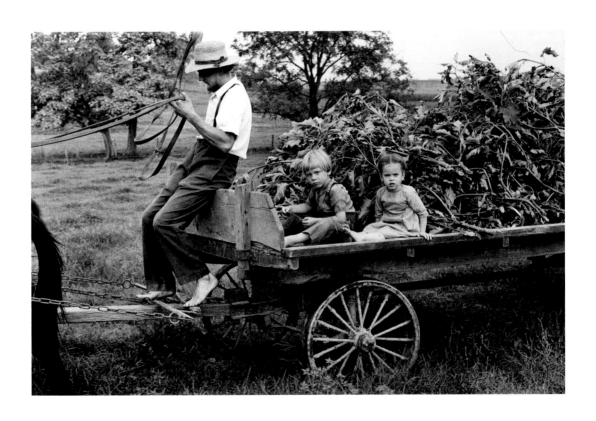

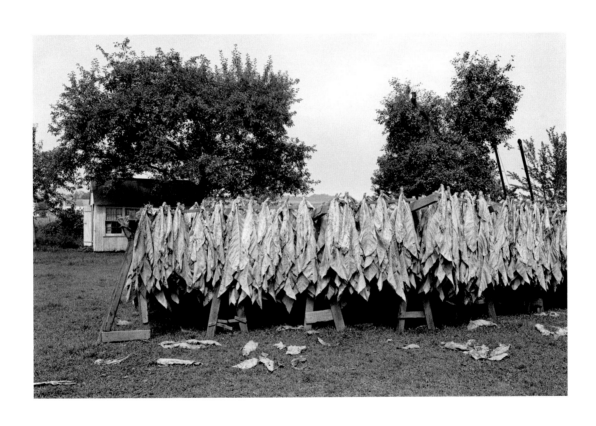

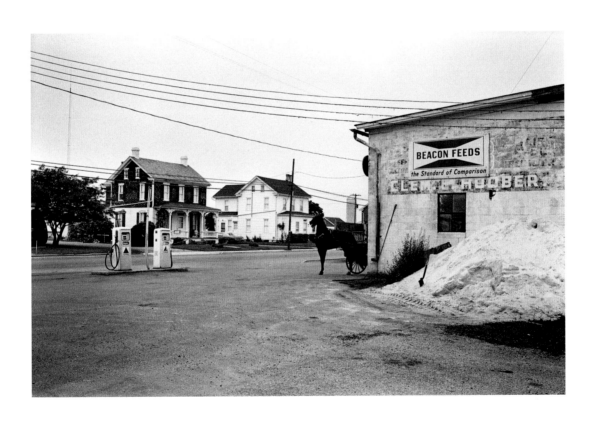

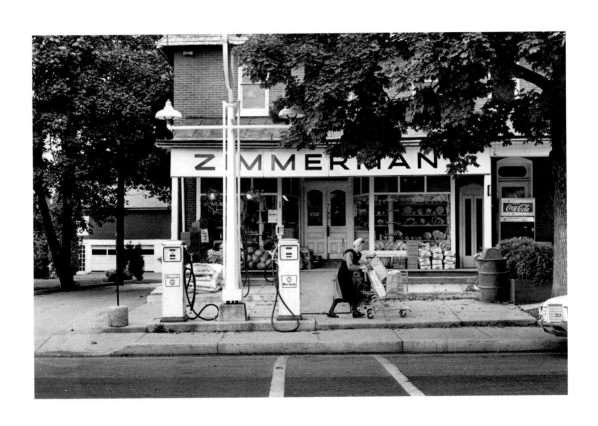

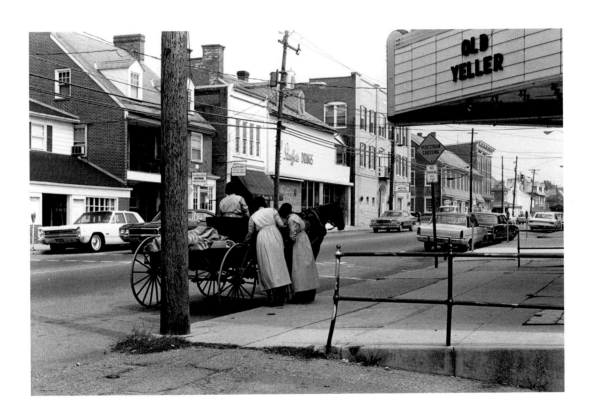

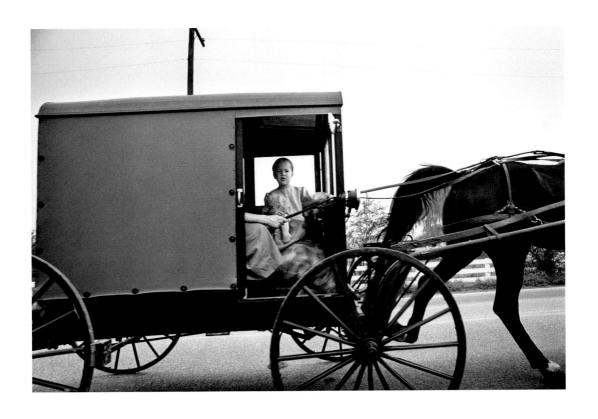

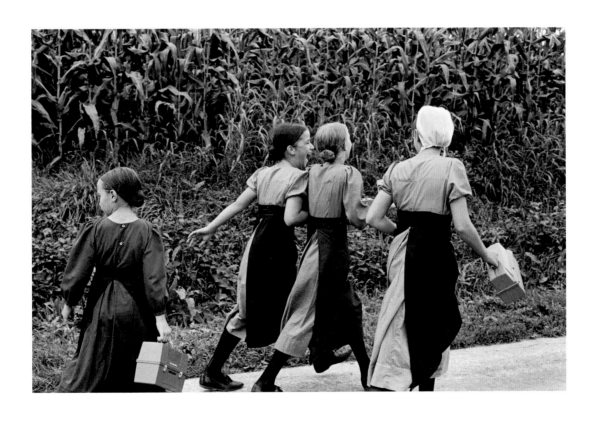

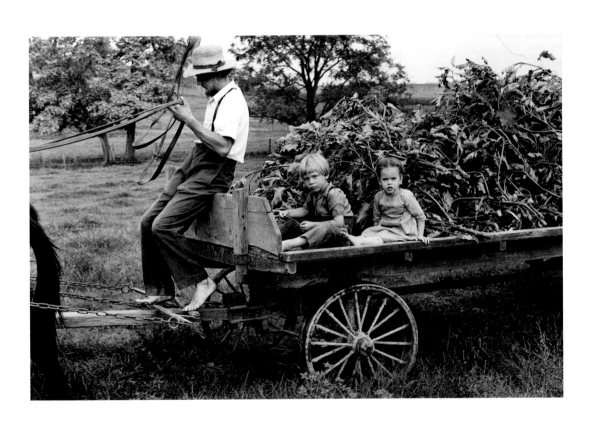

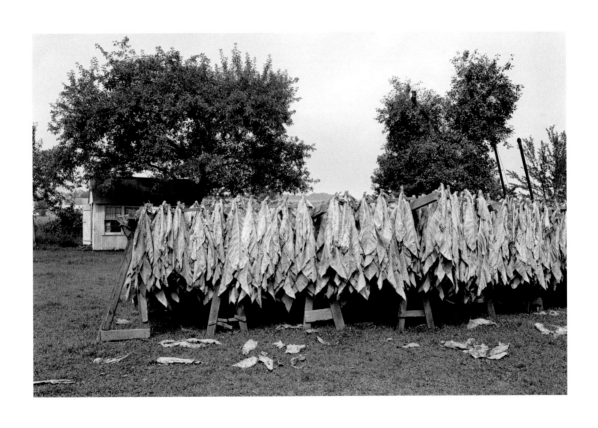

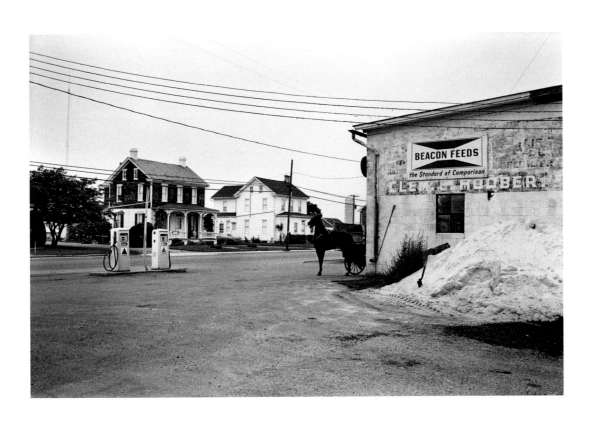

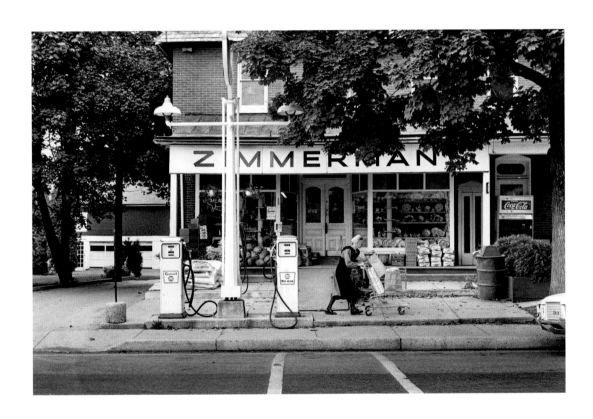

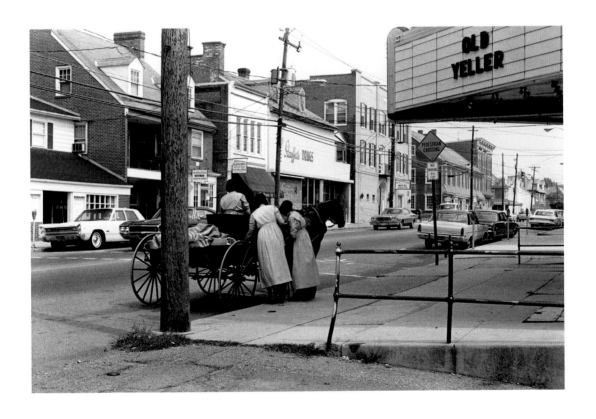

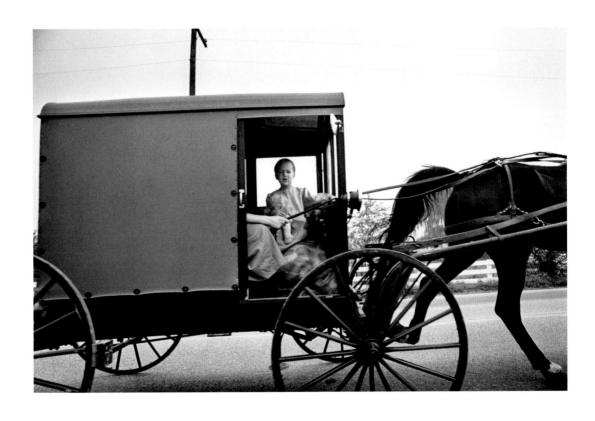

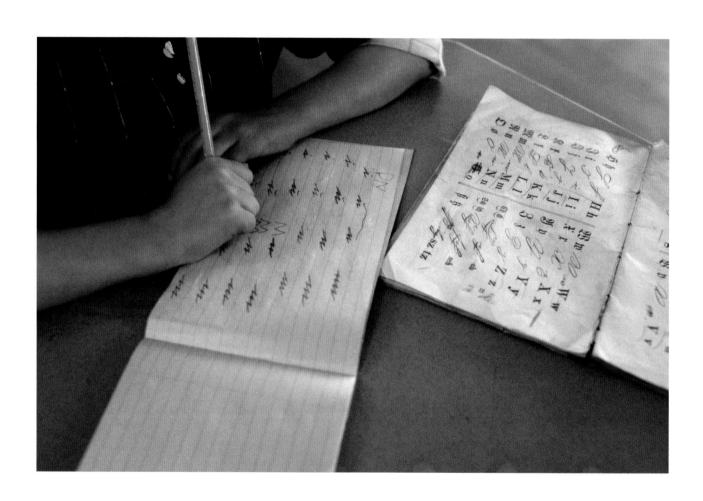

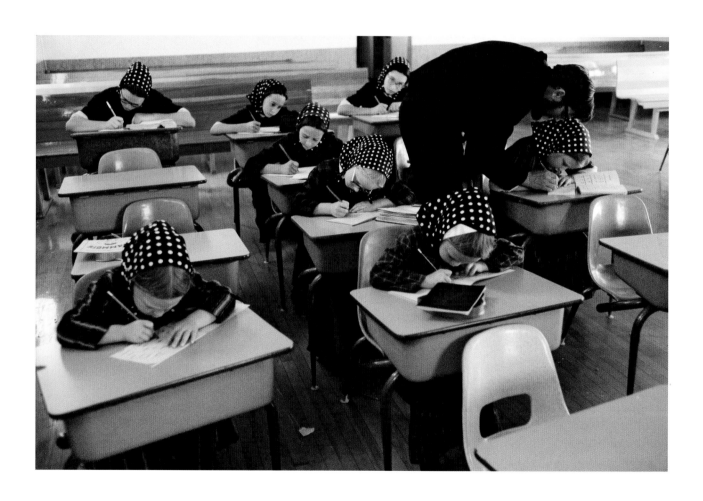

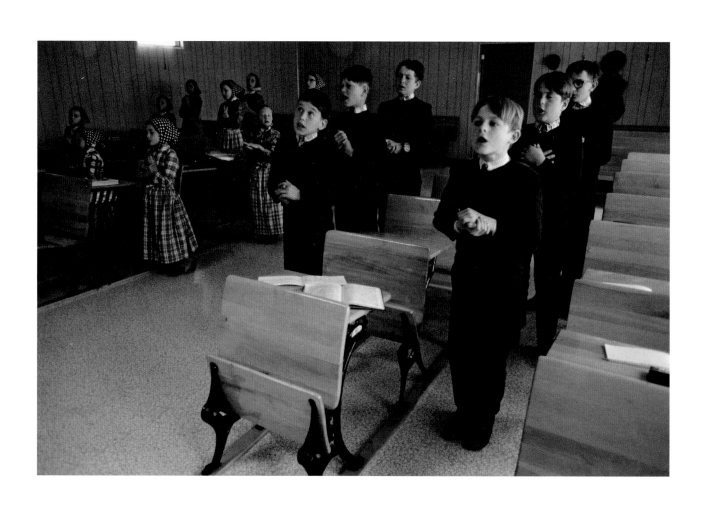

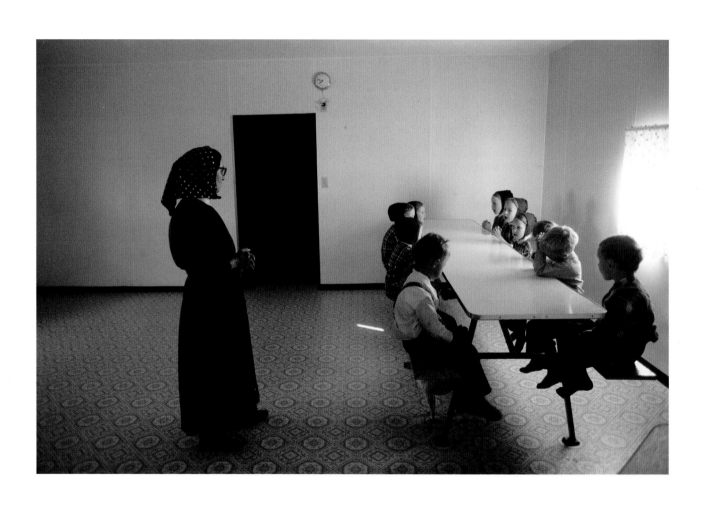

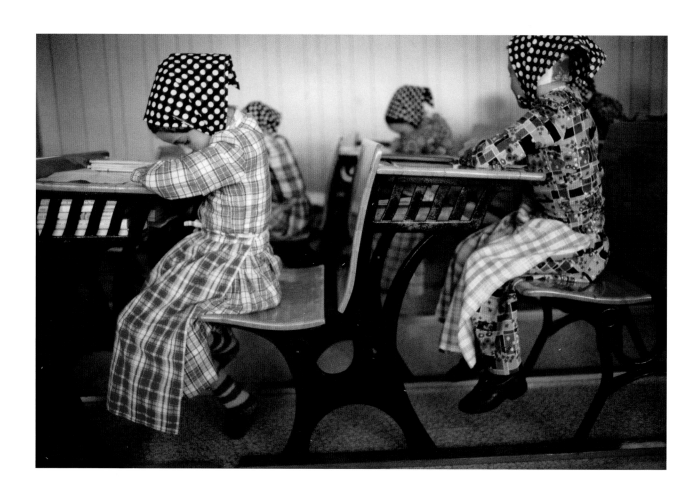

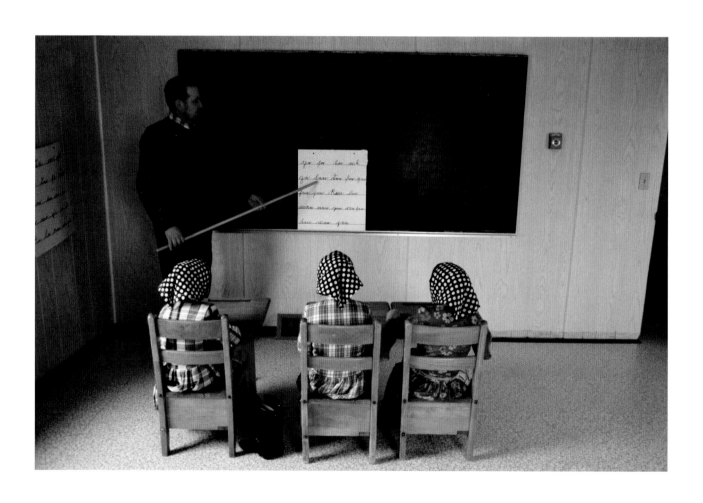

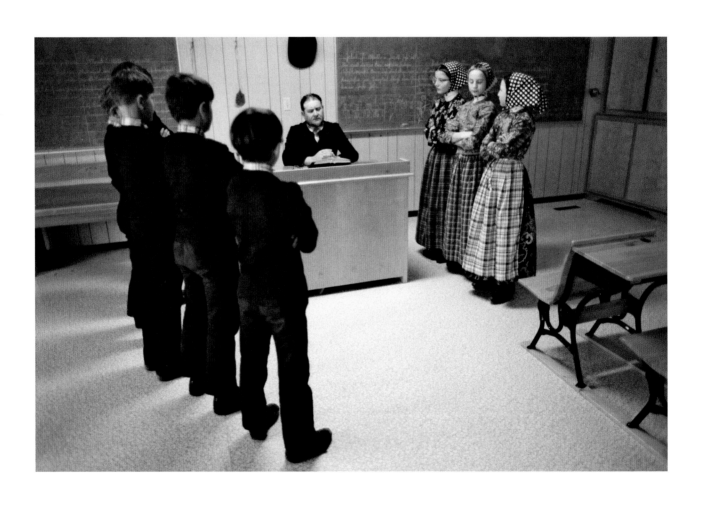

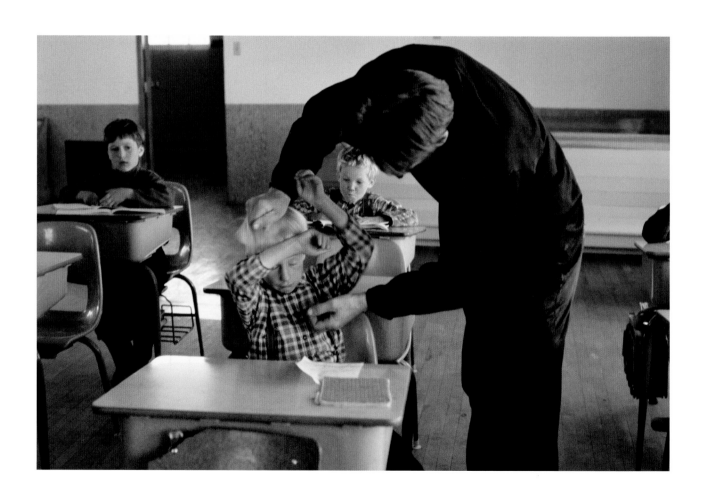

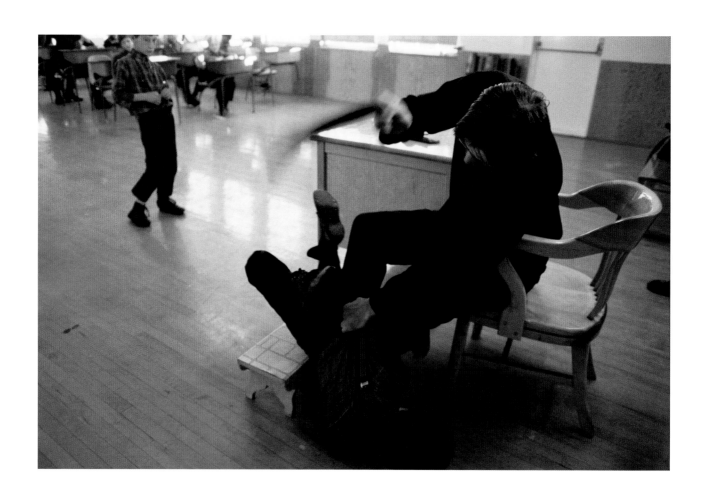

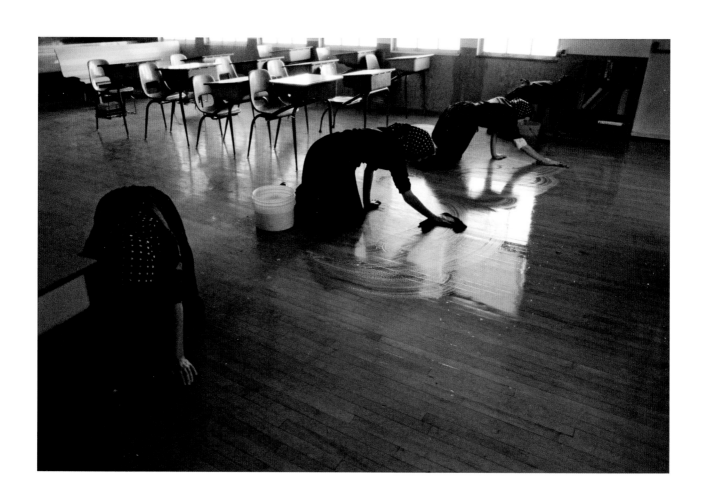

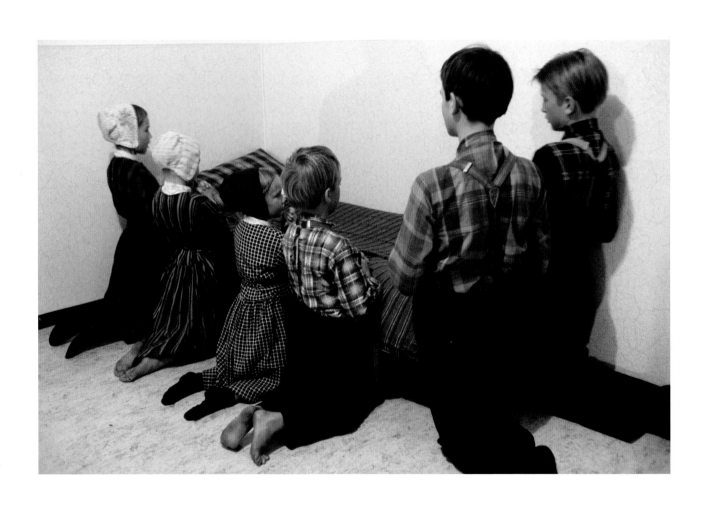

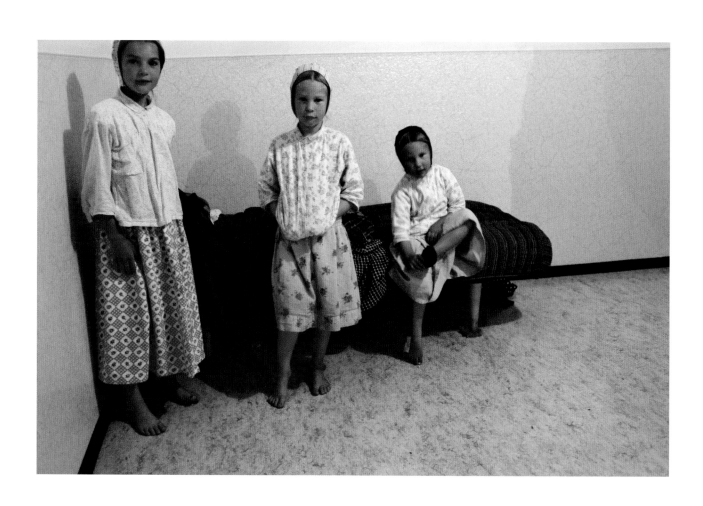

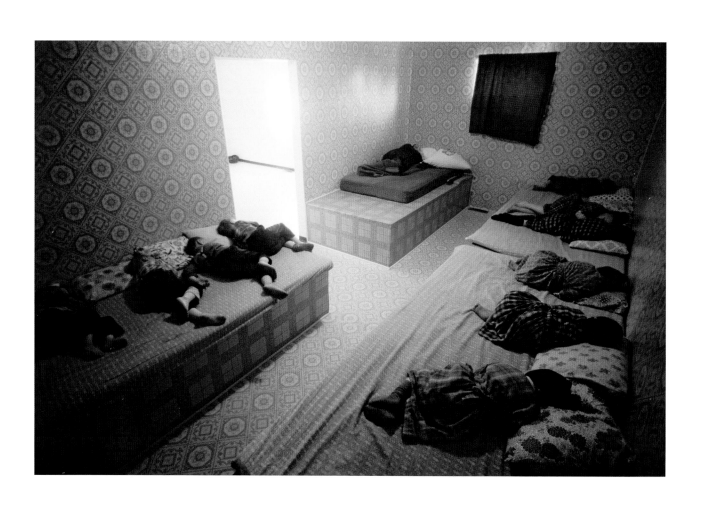

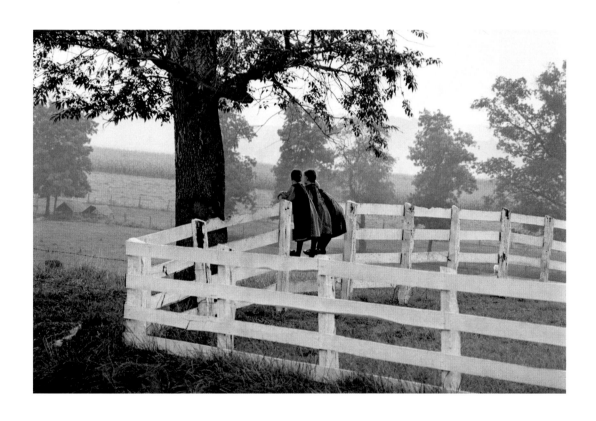

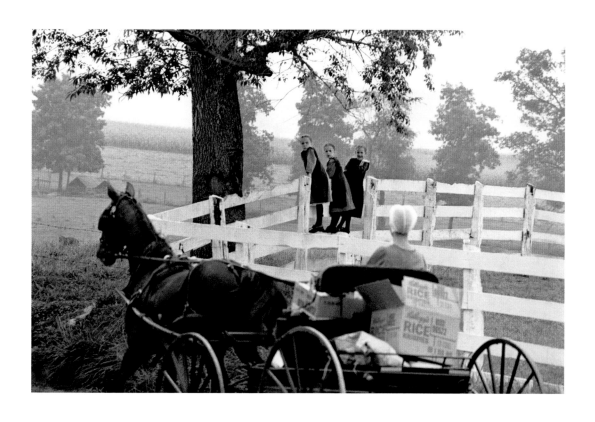

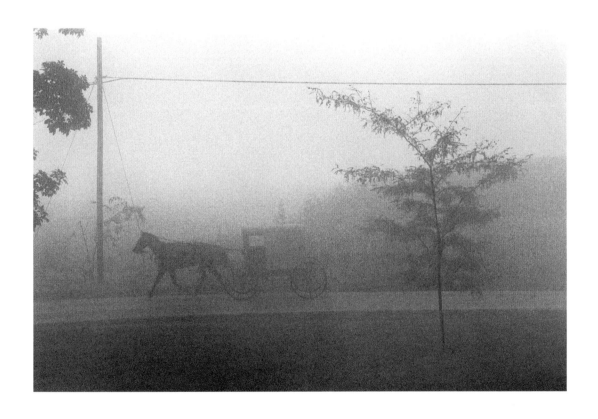

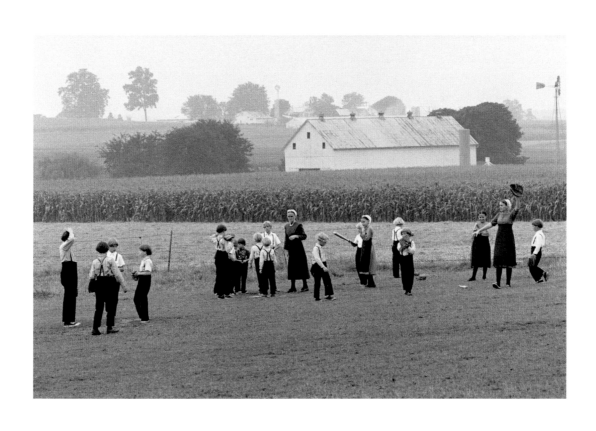

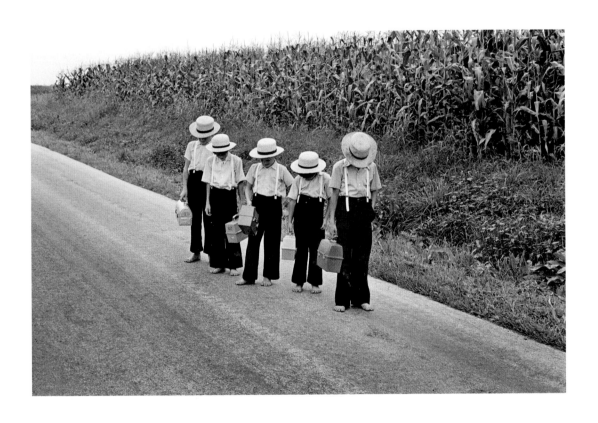

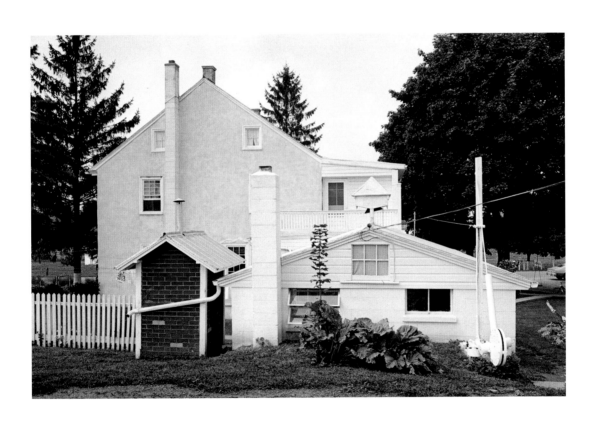

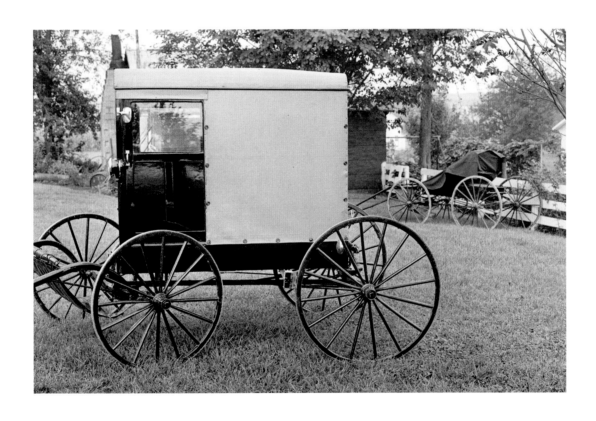

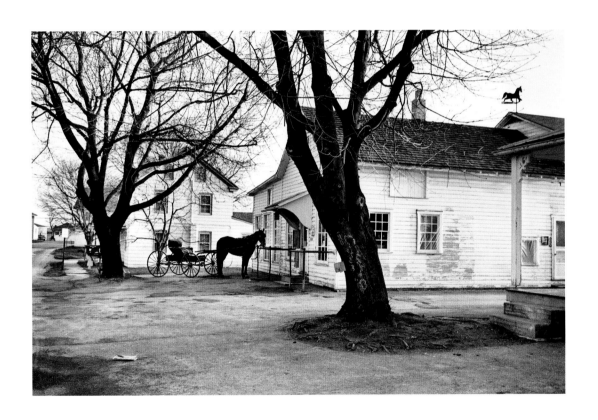

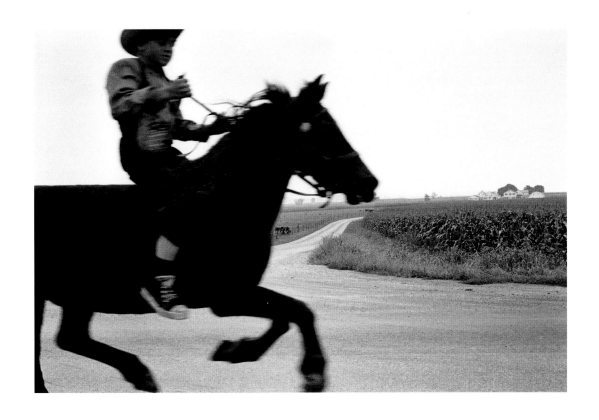

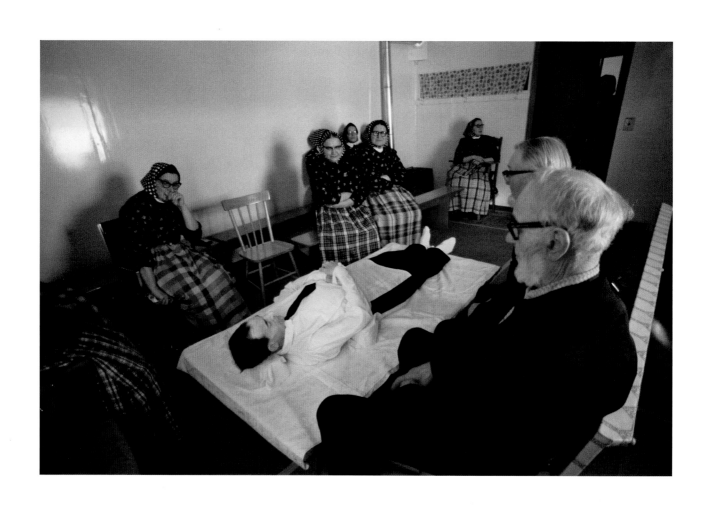

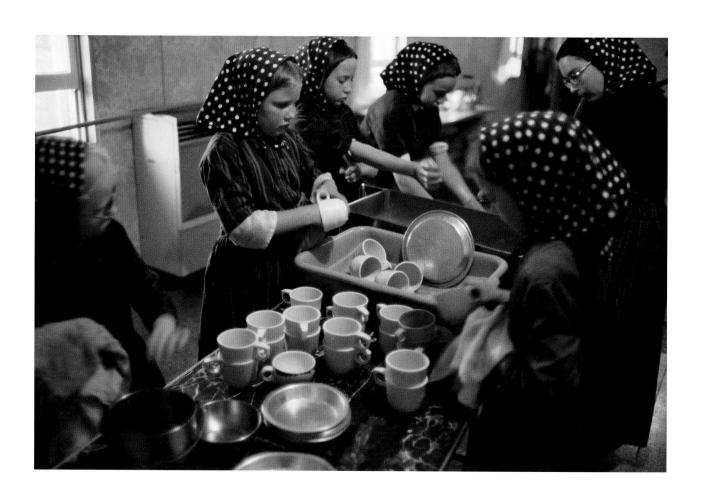

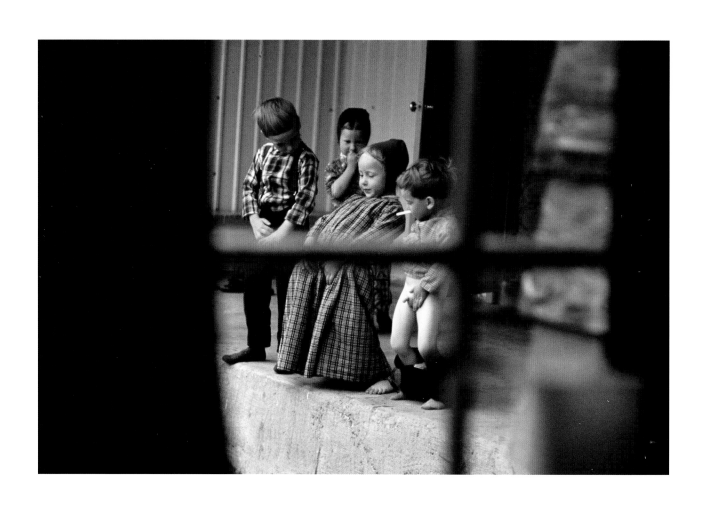

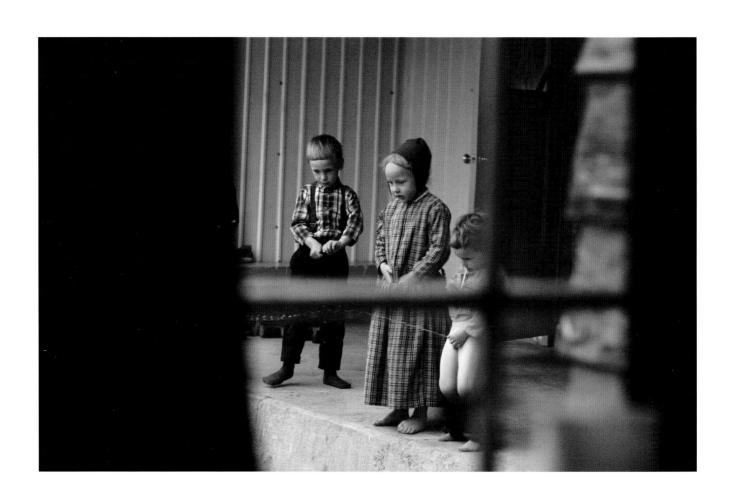

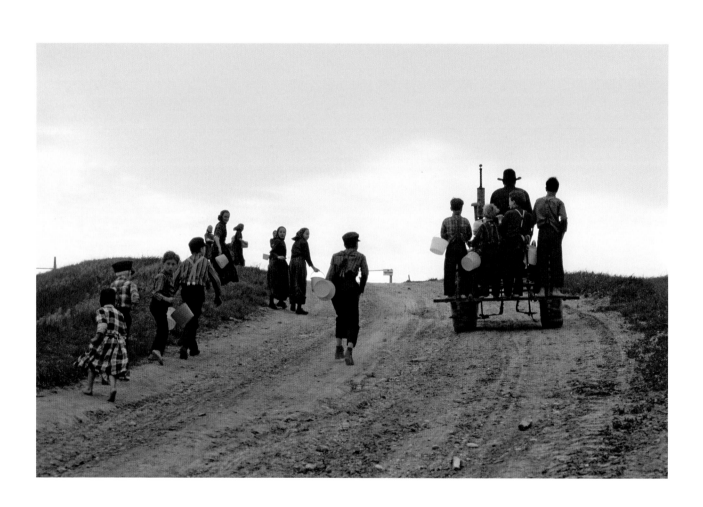

"He tacked up the enlargement on one wall of the room, and the first day he spent some time looking at it and remembering, that gloomy operation of comparing the memory with the gone reality; a frozen memory, like any photo, where nothing is missing, not even, and especially, nothingness, the true solidifier of the scene." [1]

1 Julio Cortázar, "Blow-Up," in: *Blow-Up and Other Stories*, New York 1967, p. 126. Director Michelangelo Antonioni based his film Blow Up (1966) on Julio Cortázar's novella.

• NO •
PHOTOGRAPHING

Let me explain how it was: at the time, I didn't know a thing – I was young, inexperienced, and a budding photographer. Yes, I had finished my studies, but "… here, poor fool, I stand once more // No wiser than I was before." As a *half*-Jew, christened a Protestant, confirmed, and educated at a Catholic boarding school, I was used to incense – but not just incense. The overwhelming stately governance of Catholic baroque art had knocked me out more than once during my time at boarding school. Every Friday morning during chapel service at Fulda Cathedral, I bowed my head: *mea culpa, mea culpa* … I never understood why I was guilty. However, even if my eyes were shrouded with guilt, they saw many a Catholic treasure in white, gold, and red – treasures of sublime beauty that made me believe in something higher. Things were much more modest in my little Lutheran church. It was plain, whitewashed, a simple dark wooden cross as its only decoration. The pastor, a figure wholly clad in black, uttered dry, harsh words. Grown up between these visible aesthetic extremes of religious belief, I was interested in the Bible as a means of choosing between these two worlds.

Sometimes I felt like Oscar Freedman, called Ozzie, in Philip Roth's short story "The Conversion of the Jews." [2] Ozzie believes that God can do everything – for example, that he can "… let a woman have a baby without having intercourse." However, Ozzie's religion teacher,

2 Philip Roth, "The Conversion of the Jews," in: *Goodbye, Columbus and Five Short Stories*, London 2006. All quotations from Roth's story are taken from this edition.

Rabbi Binder, does not allow any such thoughts. The rabbi tells Ozzie, "how Jesus was historical and how he lived like you and me but he wasn't God." Yet Ozzie replies that he has understood all that; what he wanted to know was "something different." The story then takes a dramatic turn. Ozzie does not change his opinion; by mistake he punches Rabbi Binder a bloody nose

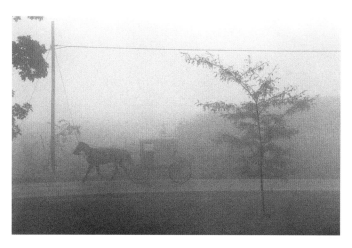

and escapes onto the roof of the school. It was Oscar Freedman's idea of "something different" that haunted me as well, me, a faithful traveler between religions.

To this day, I occasionally hear the light clapper of horses in my sleep and the rolling of iron-banded wooden wheels. Half asleep, I rush to the window and I see a gray wagon drawn by a black horse. Through the fly screen of the window, I take a first photo in the morning mist.

Lancaster County, Pennsylvania, USA, 1974 – I have rented a room with a Mennonite family offering bed-and-breakfast accommodation. I have gone to stay with a community who really believes and who lives according to the Ten Commandments of the Bible. I am with the Amish.

The Amish are an Anabaptist Protestant community of faith whose history is closely connected with other Anabaptist movements and with the Reformation of the modern era in general. The community developed in the late seventeenth century when it separated from the Mennonites. Its name goes back to Jakob Ammann, a Swiss preacher whose teachings dictate the way of life of his followers; devout people they are, detached from the civilized world, and who follow a strict regime of rules and regulations. They immigrated to America in the eighteenth century to escape persecution in Europe. Today, the largest Amish settlement of roughly 25,000 followers is found in Lancaster County, an area that they colonized between 1720 and 1730. The Amish live in accordance with the "Holy Order,"[3] which dictates their modest way of life. There is a regulation for every aspect of Amish life – from the dress code to the form of their *Dachwägele* or covered wagons. It is prohibited to drive a car or to use electricity from the public network. In the evening, the people

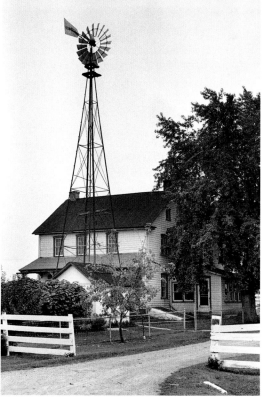

3 "The Ordnung encodes the church-community's beliefs, and so it governs nearly every aspect of Amish life. Yet it is more than simply a collection of rules; it ties the individual to the Gmay and protects the Gmay from the outside world." (Karen M. Johnson-Weiner, *Who are the Amish?*, cf. http://www.patchwork-europe.com/Who-are-the-Amish)

gather around gas lights. Windmills and water generate the electricity they need. Among themselves, the Amish speak a German dialect – so-called Pennsylvanian

German – whereas during their Sunday church services [4] a peculiar High German is spoken, interspersed with English words.

I experienced all of this as if from a raised blind, and I also read about it later on. I keep my distance – the longer I stay there, the stranger all this becomes to me. "You shall not make for yourself an image in the form of anything in heaven above or on the earth beneath or in the waters below."[5]

4 "Church as community and church as ritual come together every other Sunday when the Old Order Amish meet to worship. Like the first Anabaptists, they gather in homes, away from worldly intrusion and threat, each family taking its turn." (ibid.)

5 The third commandment, Exodus 20: 2, Translation: New Standard Revised Version.

Indeed, no photo is found in any Amish passport; fingerprints replace the passport portrait. But, ironically, the old books do not explicitly forbid photography as it was only invented in 1839. Expressly forbidden is what they call posing, the staging for the purpose of photography or another pictorial medium. Therefore, I only come across shy looks, I only see undercover gestures, lowered heads, people fleeing my camera. My small black box is a "coffin of memories."

I have entered a world in which a photographer is not welcome. Even if that photographer is still a budding artist, someone searching – someone who, like Ozzie Freedman, stands on the roof of a building and cannot jump. He happened to get up there because, like Ozzie, he wants to believe in something different from what his religion prescribes. "Being on the roof, it turned out, was a serious thing [...] Yearningly, Ozzie wished he could rip open the sky, plunge his hands through, and pull out the sun; and on the sun, like a coin, would be stamped JUMP or DON'T JUMP." Looking down from the roof, my eyesight was clearly blurred. Much later, I had learned to see everything. I was to see it all in the pictures.

A year earlier, in 1973, I had met Michael Holzach in the Ruhr district – a man with a gentle heart, well over six feet tall.[6] He was in his mid-twenties and had a degree in the Social Sciences. Coming from a wealthy family and, as expected, an ardent leftist socialist, he wanted to make the world a better place. I wished to do the same. We became friends and, for a long time, the two of us were a perfect team in the field of German journalism; he wrote the texts and I took the pictures. Both word and image were to create something new and enable a new view of things. He always doubted the use of such endeavors, and we often talked about my experiences with the Amish in Lancaster County. In 1976, Erich Fromm had published *To Have or to Be?* This book changed the mindset of many people in the late seventies, but it strongly influenced Michael Holzach's thought and life. Fromm's book begins with three quotations:

6 Michael Holzach – born in Heidelberg in 1947 – studied Social Sciences in Bochum; he was a cub reporter at *Westfälische Rundschau*, Dortmund, and after that a reporter for *ZEITmagazin* in Hamburg. His first book, *Das vergessene Volk* (The Forgotten People), was published in 1980 – that same year, he traveled through the Federal Republic of Germany for six months. In 1982, *Deutschland umsonst* (Germany for Free) appeared. In April 1983, Michael Holzach died in an accident.

The Way to do is to be.
Lao-tse

People should not consider so much what they are to do,
as what they are.
Meister Eckhart

The less you are and the less you express of your life –
the more you have and the greater is your alienated life.
Karl Marx

This, in a nutshell, was sufficient at the time for people to become restive and start thinking. In these texts, Michael read more about radical humanists like Albert Schweitzer and Ernst Bloch, but also about religious communities that rejected property and self-centeredness. Together with Fromm, he discovered the Hutterites. He wanted to learn more and came across a small book by Lydia Müller entitled *The Communism of the Moravian Anabaptists.*[7]

7 Lydia Müller, *Der Kommunismus der mährischen Wiedertäufer*, Schriften des Vereins für Reformationsgeschichte, Year 45, vol. 1, Leipzig 1927.

Later on, Michael Holzach wrote: "At the time when I read this book, there was already much talk about an 'alternative life-style,' and I, too, was sick of the society of consumption and tired of wealth. After my university education, attracted by possessions and success, I was proud to have gotten a secure job as a reporter for the well-respected magazine *Die Zeit* and was not ashamed of my fat bank account."[8]

8 Michael Holzach, *Das vergessene Volk – Ein Jahr bei den deutschen Hutterern in Kanada*, mit Fotos von Timm Rautert, Hamburg 1980, p. 39. Translation taken from Michael Holzach, trans. Stephan Lhotzky, *The Forgotten People – A Year Among the Hutterites*, with Photos by Timm Rautert, Sioux Falls, SD, 1993, p. 38.

To Have or to Be? – Michael gave up his well-paid job and, early in 1978, he flew to Canada to spend one year with the Hutterites. He wanted to write a book about his experiences there and actually succeeded in being accepted into one of their communities; he then required photographic images for this book.

I had my doubts, but in May of the same year I found myself standing at Lethbridge Airport in the Province of Alberta, Canada. I visited Michael Holzach twice during his time with the Hutterites – and altogether I spent a period of three months there.

A group of men, clad in black, is awaiting me, and in this group with his black hat Michael looks much taller than I remember him. We reach the community of Waterton situated in the foothill region of the Rocky Mountains. The men do not say a word; it is as if I am not present at all. Michael looks worried. After a drive of more than one hour, we arrive at "The Ark in the Sea of Sins," the *Bruderhof* community of Waterton. Six gray huts, one row to the north, another to the south. To the east there is the large communal kitchen, the school is in the west. At a distance the workshops, the stables, and barns. This is a lonely colony lying at the feet of massive mountains – the Big Chief, the Black Rock, and the Three Sisters, with an altitude of almost 3,000 meters

(9,850 feet). The solitude of all Hutterite colonies, deliberately chosen, is a means of dissociating the colony from the sea of sins, the evil world outside. Out there, Satan reigns over the *Maulchristen* who are merely Christian in words, but not in deed.

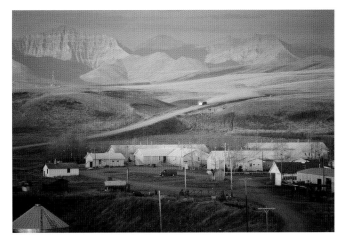

The Hutterites are an Anabaptist church of the early sixteenth century, founded by Jakob Hutter of South Tyrol. As "communist Mennonites," they live in communal societies. Like the Amish, they were persecuted and, from 1874 onwards, settled in North America after a long period of migration from one European country to another. In contrast to the Amish, the Hutterites not only accept technology; on the contrary, they constantly invest in the most modern harvest machinery as well as in cars and vehicles. Today, there are still 45,000 followers of the Hutterite religion living in North America in about 460 colonies of 60 to 150 inhabitants each. Uncompromisingly, they adhere to their church's old beliefs and customs:

1 *Adult baptism*

2 *Excommunication and admonition as only punishments for keeping the religion pure*

3 *Observance of communion as a memorial supper*

4 *Isolation from the evil world*

5 *Election of a preacher by the community, which must dismiss him when found guilty*

6 *Rejection of all worldly power such as military services, jurisdiction, and public offices*

7 *Refusal to take an oath* [9]

9 Cf. Helge Martens, *Die wiedertäuferischen Hutterer*, 50. Meeting of the Humboldt-Gesellschaft on December 17, 1997. Martens writes: "A report of Hutterite nature is, however, best found in an unscholarly work by Michael Holzach, who published his observations and experiences during a one-year stay on a Hutterite Bruderhof in a book entitled *The Forgotten People* in 1980. This publication helped to turn academic as well as public attention to the German-speaking group." (cf. http://www.humboldtgesellschaft.de/inhalt.php?name=hutterer, trans. A. Kossack)

Like the Amish, the Hutterites speak a peculiar, old-fashioned German (the early New High German), in which Bavarian-Austrian elements dominate as further ways of distinguishing themselves from the English-speaking outside world.

"And here, poor fool, I stand once more ..."

Waterton – so distant from my world and, once again, there is the ban on portraits as ordained by the Bible. They make do without a driver's license, they use provisional documents that need to be renewed every three months only to avoid

being photographed. They present birth certificates in lieu of normal passports. To justify this, they cite the third commandment as well as the third book of Moses (26, 1): "You shall not make for yourselves idols, nor shall you set up for yourselves an image or a sacred pillar ..."

At this point, dear Readers, it is necessary to quote a longer passage from Michael Holzach's book: "That pictures are not allowed, my friend the photographer Timm Rautert experienced when he visited me at the colony in the spring, and, later, in the fall. Timm wanted to take pictures for the planned book about my life in the community of chosen ones, but more than two weeks passed before he dared even to take the camera out of his suitcase. A long-winded discussion with the brethren about whether or not it was a sin to take pictures had preceded. It wasn't enough just to write about the community, the photographer argued; words on paper, even big words, may not be enough. Therefore, he said, the book needed illustrations so that the readers in Germany could see with their own eyes that the Hutterites still live according to the old faith, in spite of all persecution. The holy ones were intrigued by this worldly argument. The preacher thought that it was necessary so that 'the people in Germany can see what a life in righteousness looks like.' On the other hand, there was no explaining away of Moses' laws either. After heated debates in the community council, the brethren therefore agreed on a Solomonic compromise and decided neither to permit the taking of photographs nor to refuse permission. They wisely overlooked Timm Rautert when, with a black conscience, he once in a while pushed the release button; this didn't happen too often, because Timotheus, as the Hutterites called him in a biblical manner, had to work hard on the farm. 'Fortunately,' in their view, he would not have much time to snap pictures during the building of fences, the feeding of cows, and the castrating of piglets."[10]

10 Michael Holzach, *The Forgotten People*, pp. 73f.

Thus, although my activities are not allowed, they are not forbidden either. Word and image, image or word: the words are smuggled out of my head, the images are kept in my "little coffin of memories." They watch me when I zoom in with my camera. What kind of picture hidden on that layer of film will come out later? Nobody can tell. Lonely and a stranger – to this day, I believe that I never looked more like a stranger – there I stood in *mundane* clothes between the bearded men all clothed in black. I will never forget the day: it was Friday, May 19, 1978.

A cool wind is blowing down from the mountains, dusk is falling, prayers and dinner have just finished. I am guided to a dark room, entirely different from the smooth, gray and white rooms lined with plastic that I come to see later in the family quarters. I no longer know with whom I spoke about whatever it was, but I do remember that they paid great attention to my *Deitsch*. A lot is won if one speaks their holy language or *heiliga Sprach*.

Language and belief are closely interconnected for the Hutterites, and in these they clearly distinguish themselves from their surroundings; their clothing is important as well. Michael had passed on my measurements and on the wide bed – there is nothing else in the room besides a chair and table – my new black clothes are laid out: a vest with hook and eyelet, wide trousers with suspenders, a white shirt for Sundays, and dark black shoes. Indeed, everything is extremely respectable, *demiatig*. Later on I learn all about the women's clothing. The Bible says, "Sin began with a woman [...]" (Sirach, 25). That is the reason why Hutterite women have to cover up everything that might arouse a feeling of lust in the eyes of men. Every Saturday after their weekly bath, the women's long, uncut hair is hidden under a twofold head covering, a cap *(Mitz)* with a dotted scarf *(Tiechl)*. The checkered skirts must not rise higher than eight centimeters above the ankle.

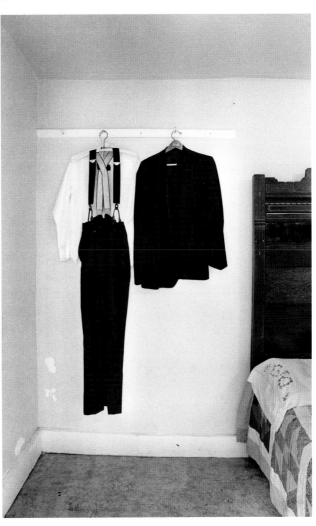

Newly dressed but in shoes that are far too big, Michael and I make our way to God's deputy in Waterton, the preacher Elias Wurz. The room is very warm and we are given the privilege to take a seat on two rather uncomfortable chairs. There is a long, persistent silence. Then Elias Wurz asks me about the state of the German language *(Deitsche Sprach)* and the well-being of the Kaiser, how the Catholic *(Kathole)* was doing, and if I had come by zeppelin *(Luftschief)*. My request is disregarded. Next to the preacher I also get to know the other most important men: the four brothers of justice who are elected by the *Stiebl*, the assembly of all baptized men. They are the *Säckelmann* or landlord likewise called Elias Wurz, the preacher's father, then comes the *Weinsedel*, Johannes Hofer, who is responsible for the organization of the chores and work, then the teacher Paul Hofer and his brother Georg, in charge of 2,000 chickens. Early next morning at half past six, the bell rings to wake us. At 7 a.m. everybody gulps down their breakfast, hastily and discontented. Then, the *Weinsedel*

delegates the day's work in front of the Kuchl consisting of all male colony members who no longer go to school. I, Timotheus Vetter, as they call me, naturally have to work like the others and am taught to perform difficult jobs. I learn to ride without a saddle, I kill ducks, brand calves, harrow giant fields, kill pigs in icy-cold weather – and in the evening, I am exhausted. My real profession is forgotten, I have become a farmer; even if the food is unbalanced and served hastily, I am well looked after. At the beginning of the month, like any other member of the colony older than fifteen, I get a liter of *Blemelwan*, a very sweet alcoholic drink fermented from dandelion. At night, I look at my cameras and drink of the dandelion wine.

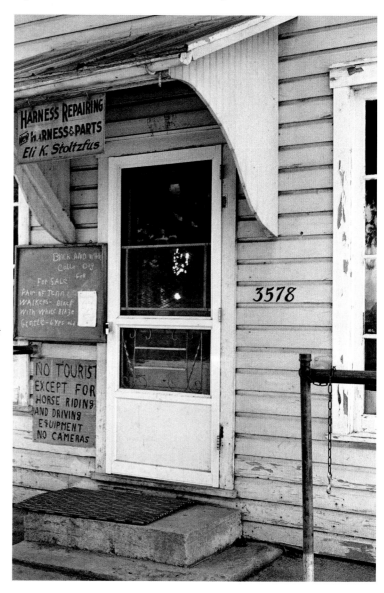

The harmony that controls both work and life here is impressive. I neither hear a bad word, nor sense jealousy or greed. The idea of "being" is offset by the responsibility for communal property and ownership. And the following is decreed in one of the Hutterite "orders": "Because all of God's gifts, not only spiritual but worldly gifts as well, have been given to man so that he should not own them himself but share them with his comrades, be it established within the holy community that no one shall live in affluence and another in need but that all shall be equal." The opposition between mine and yours have brought about much misery on earth: "For the words 'mine' and 'yours' have caused many wars and still cause them today. For those who succumb to 'mine' and 'yours' – that is, private property – are friends with greed and his two daughters that are the bloodsuckers of the shameful worm of greed, and their two names are 'Give me.'" [11]

Not a fortnight, no, three weeks have already passed since my arrival; I should really start taking photographs. From time to time, I carefully pick up

11 Peter Riedemann, *Rechenschaft*. After the Bible, Riedemann's *Confession of Faith*, which the author wrote in 1540 while confined in prison in Nuremberg, is one of the fundamental texts of the Hutterite religious belief, cited in: Michael Holzach, *The Forgotten People*, p. 126.

my rather small Leica M4 – it is as black as my clothes. I begin in the dining hall so that everybody can see my little box. The women are seated on the left, the men on the right, three tables on either side. Although there are a couple of windows, the hall is very dark. The bulbs on the ceiling are only switched on in the evening and in winter. I always sit together with Michael, the preacher, the *Säckelmann*, and the teacher at the third table, the farthest in the back. I make an announcement at the table but get no reply, so I stand up and take one single picture. The spell is broken, but I felt very uncomfortable when taking it. Never before and never afterwards did I feel more superfluous as a photographer and, although nobody looked at me, I had the impression that they were all staring at me.

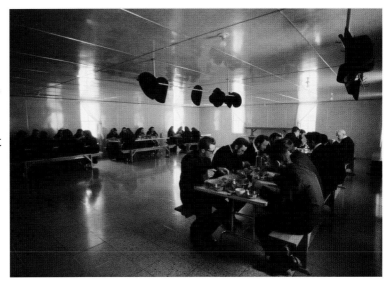

However, photography was my medium and, through it, I wanted to report about an apparently long-forgotten, past world. The fact that I had created this world with my camera and that, in reality, it really was "something different," this I did not realize at the time. The project, however, was to influence my future photographic work. I had great faith in photography. Although I was in actual fact *inside*, in the very midst of all activities, I found myself standing outside – like Oscar Freedman on the roof of the school. The crowd in the street is afraid that Ozzie will jump if his wishes are not met. He calls down into the crowd from the roof:

"Rabbi Binder, do you believe in God?"

"Yes."

"Do you believe God can do Anything? [...] Tell me you believe God can do Anything."

There is a second's hesitation. Then: "God can do Anything."

"Tell me you believe God can make a child without intercourse."

"He can."

In the meantime, the firemen have spread out a yellow net. Ozzie has got what he wanted, and he can come down from the roof.

"And he did, right into the centre of the yellow net that glowed in the evening's edge like an overgrown halo."

Timm Rautert

This book is dedicated to my friend and companion Michael Holzach, who died far too early.

I would like to thank Gerhard Steidl for his constructive support and his belief in complex, analogue projects.

First edition published in 2011

Book design by Oliver Klimpel, London
Translated from the German by Ariane Kossack
Scans by Steidl's digital darkroom
Production and printing: Steidl, Göttingen

STEIDL
Düstere Straße 4 / 37073 Göttingen
Tel. +49 551 49 60 60 / Fax +49 551 49 60 649
mail@steidl.de
www.steidl.de / www.steidlville.com

ISBN 978-3-86930-322-2
Printed in Germany by Steidl